THE IRON TONIC

THE IRON TONIC:

OR,

A WINTER AFTERNOON

IN

LONELY VALLEY.

BY

EDWARD GOREY.

DEY ST.

AN IMPRINT OF
WILLIAM MORROW PUBLISHERS

www.harpercollins.com

The Iron Tonic was first published in 1969 by Albondocani Press
in a limited edition printing of 226 copies.

ISBN: 0-15-100437-4

Library of Congress
Cataloging-in-Publication Data available
on request.

23 RRDA 10 9 8

Printed in Malaysia

To the memory of Helen St John Garvey

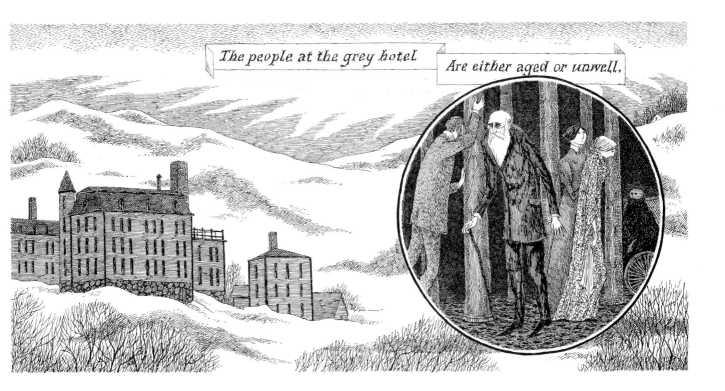

The people at the grey hotel

Are either aged or unwell.

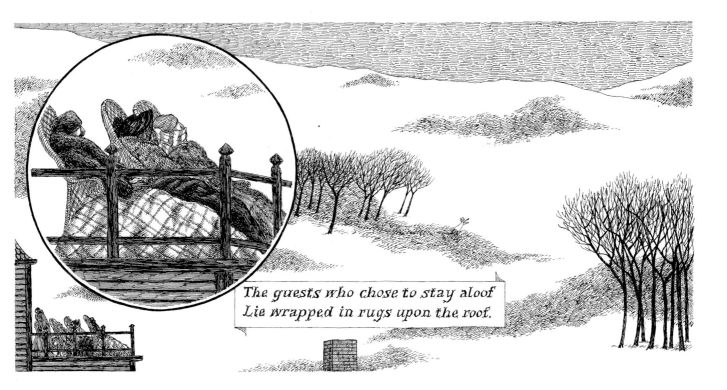

The guests who chose to stay aloof
Lie wrapped in rugs upon the roof.

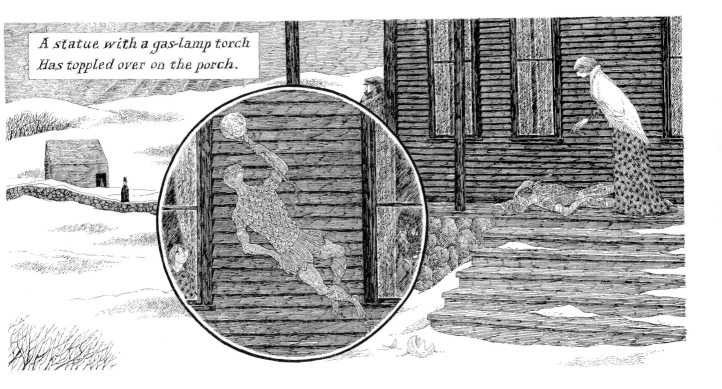

A statue with a gas-lamp torch
Has toppled over on the porch.

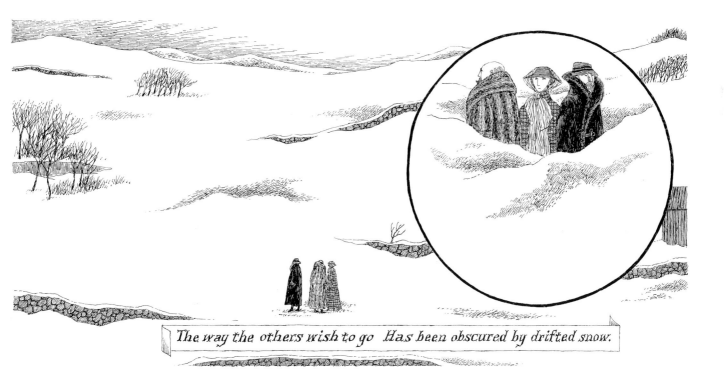

The way the others wish to go Has been obscured by drifted snow.

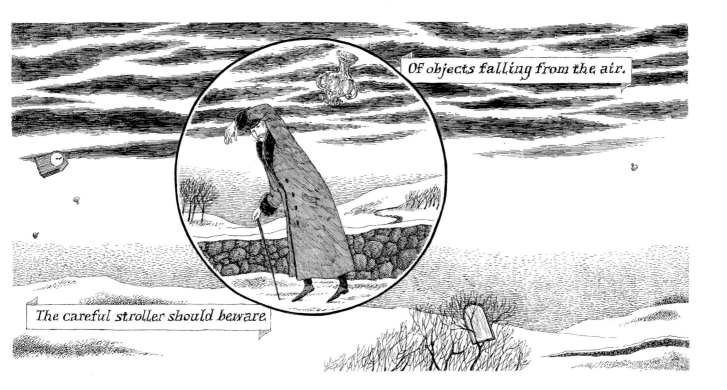

Of objects falling from the air.

The careful stroller should beware.

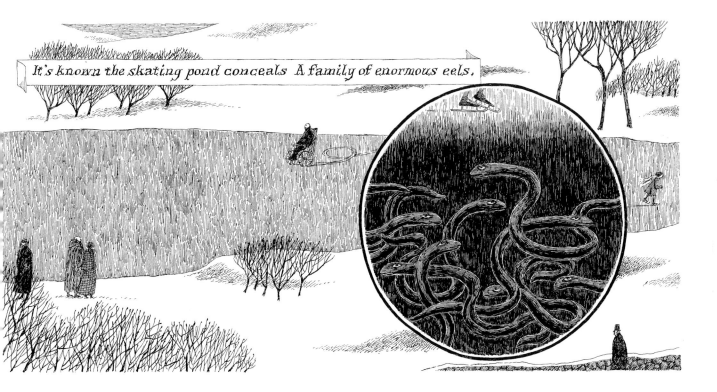

It's known the skating pond conceals A family of enormous eels,

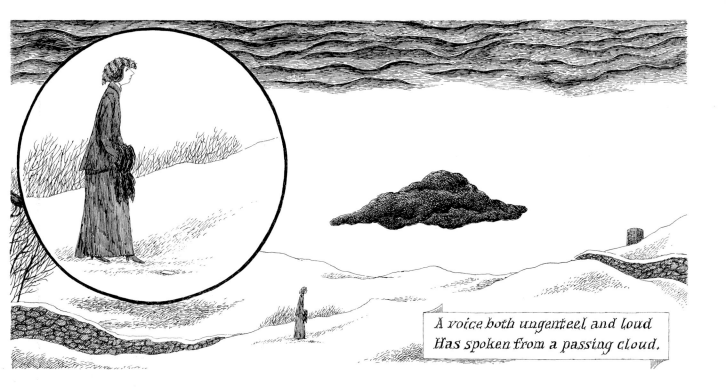

A voice both ungenteel and loud
Has spoken from a passing cloud.

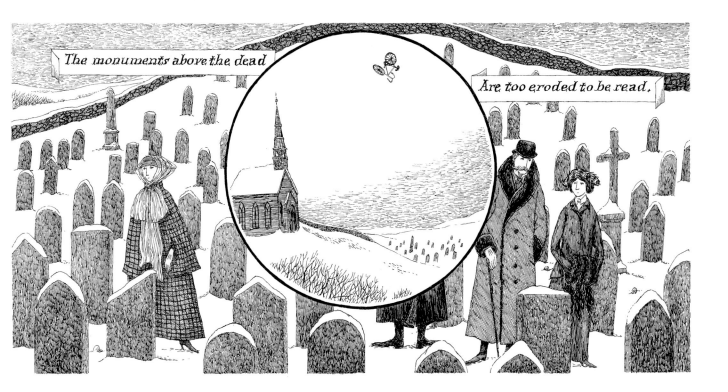

The monuments above the dead

Are too eroded to be read.

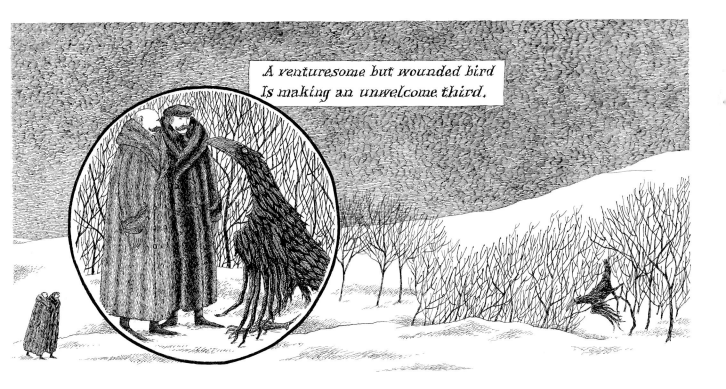

A venturesome but wounded bird
Is making an unwelcome third.

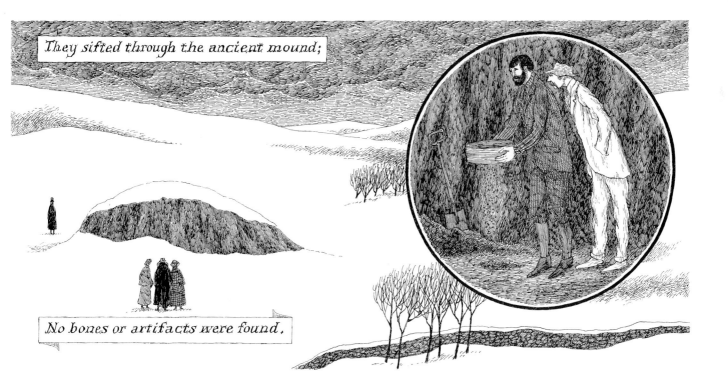

They sifted through the ancient mound;

No bones or artifacts were found.

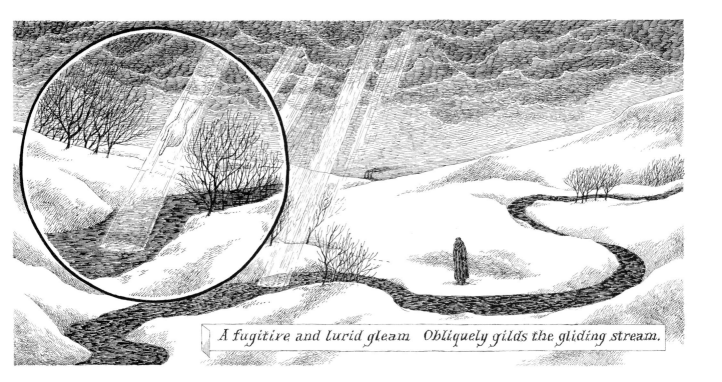

A fugitive and lurid gleam Obliquely gilds the gliding stream.

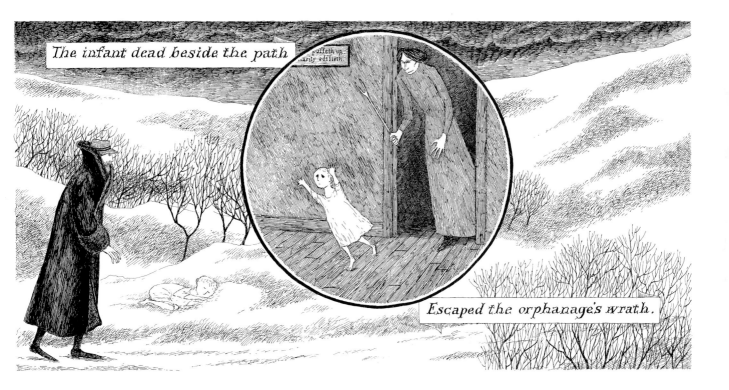

The infant dead beside the path

Escaped the orphanage's wrath.

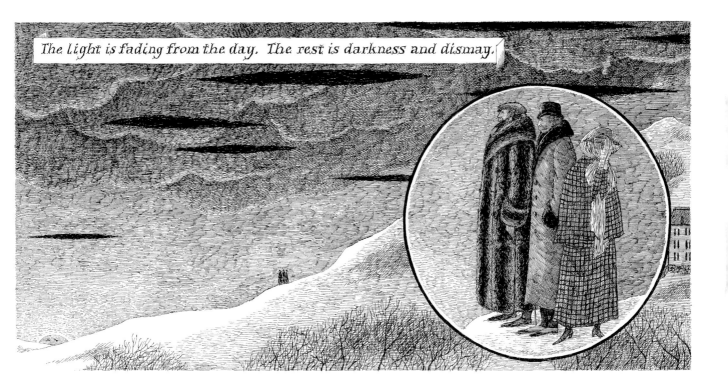

The light is fading from the day. The rest is darkness and dismay.

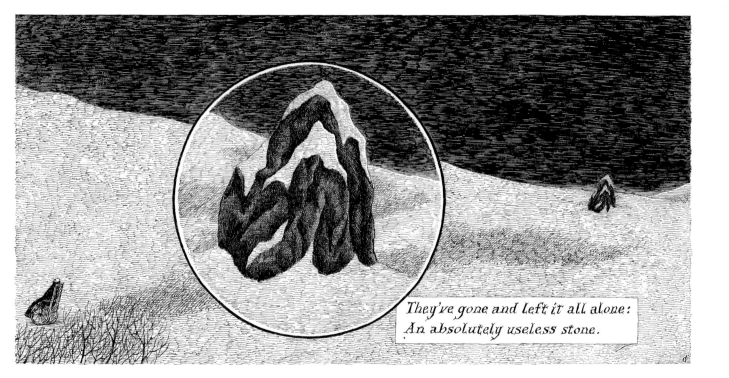

They've gone and left it all alone:
An absolutely useless stone.